ABC's of Life

Copyright © 2016 Marita Gale

All rights reserved.

ISBN-10: 1537442597
ISBN-13: 978-1537442594

Acknowledgments

I would like to acknowledge and thank God for all of my life's experiences teaching me to forgive and to live each moment in grace which led to the creation of this simple and profound "ABC's of Life" coloring book.

I would also like to acknowledge and thank all the dogs and cats I have had the honor of pet sitting and/or walking since living in Sedona, Arizona. They were my teachers of unconditional love.

Last, but not least, I would like to acknowledge and thank my inner child I rediscovered while creating this book opening my heart to what life is truly offering me — a new way to be — living fully in my creativity.

ABC's of Life

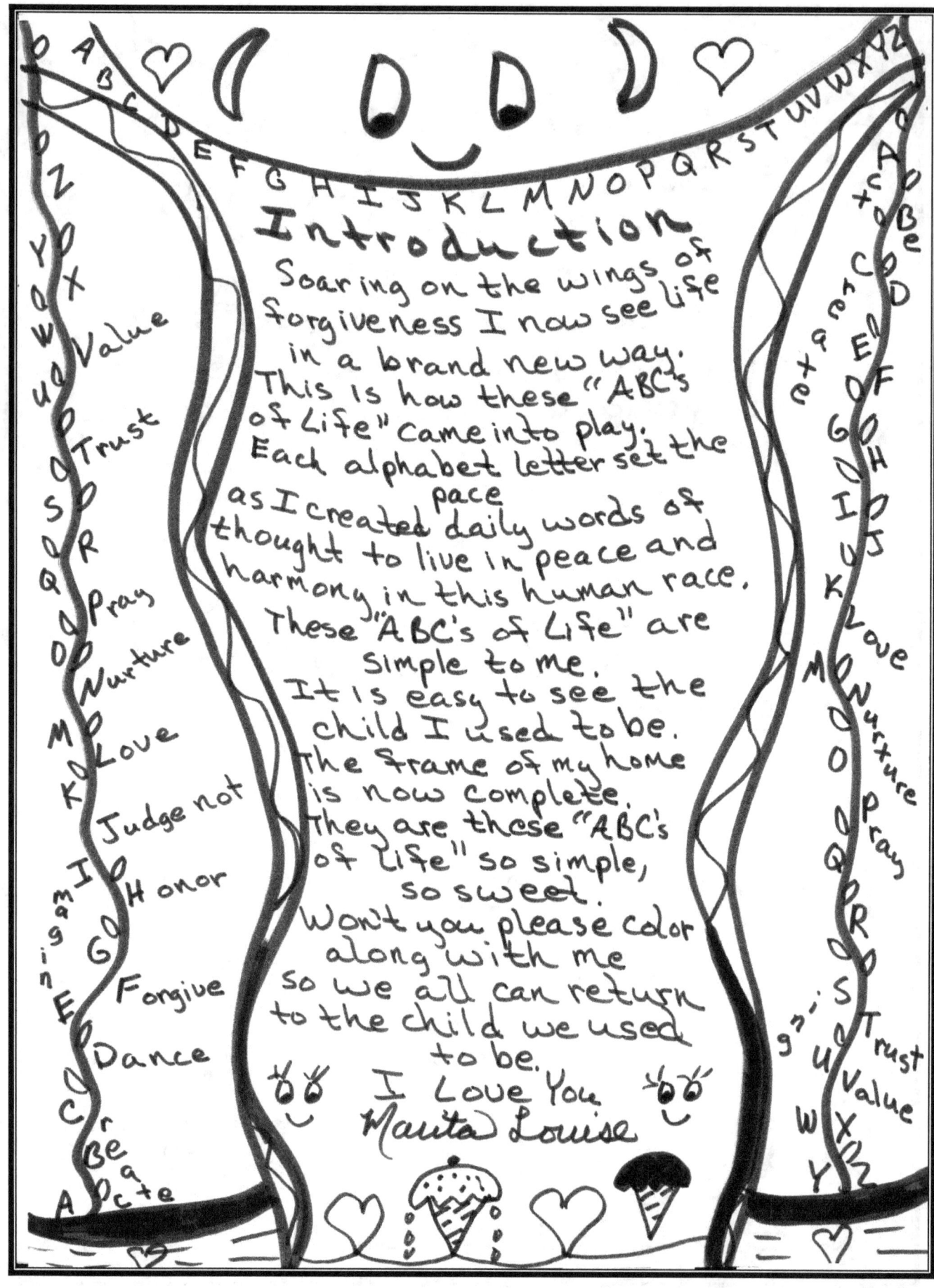

♡ ABC's of Life ♡

Act with integrity. ♡
Be who you are. ♡
Create in the moment. ♡
Dance and Dance some more.
Expect nothing. Embrace everything.
Forgive often. ♡
Greet everyone with a smile. ☺
Honor and respect each other. ♡
Imagine a universe of peace. ☮
Judge not and you will not be judged. ♡

Know you are loved. ♡
Love like never before. Let your Love pour all over the universe.
Marvel at the beauty in nature.

Nurture yourself with kindness.

Offer to help your neighbor.

Pray for peace. ☮

Question everything. ?oo?

Remember who you are - a bright shining star. ✨

Sing to the one you love ♪♫

Trust yourself. ♡ ♡

Understand one another. ♡

Value life. It is a most precious gift. ♡ ♡ ♡ ♡

Walk your talk, whatever that may be. ○°°°○○ 8 8 °○ ° 8

X marks the spot. It's easy to see.

Yearn no more, just open the door;

Zero in on life and away you'll go, moving with the flow.

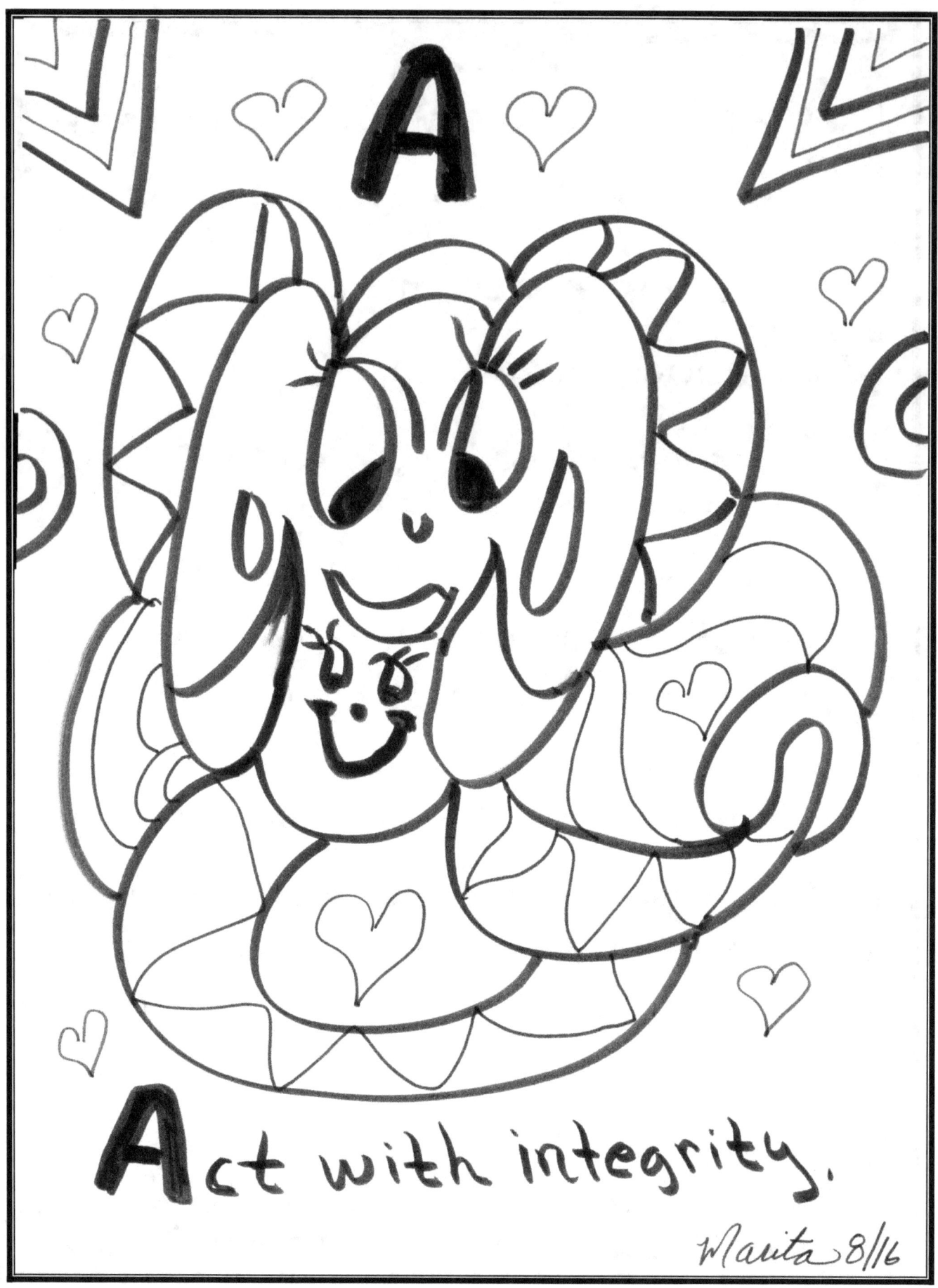

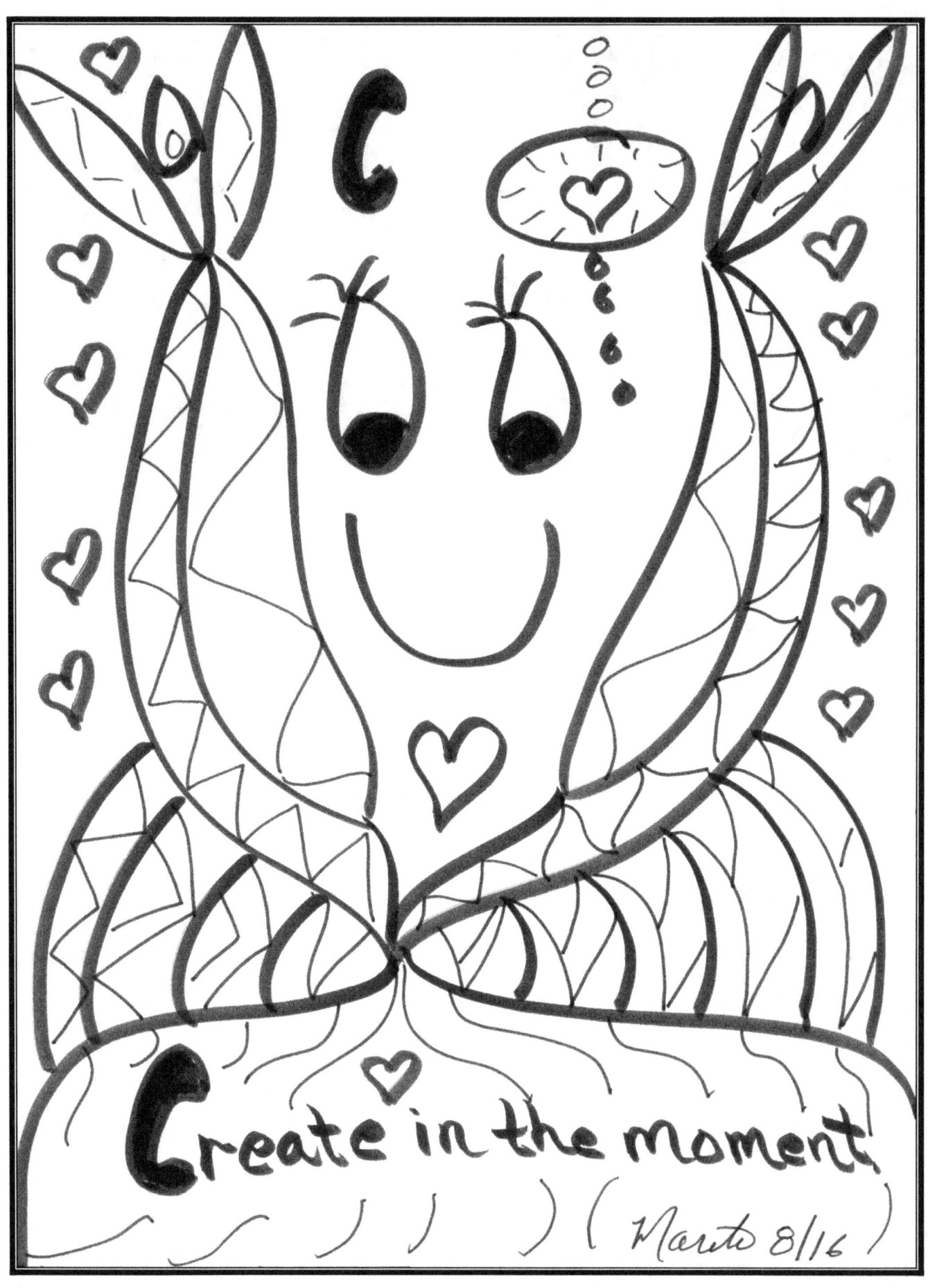

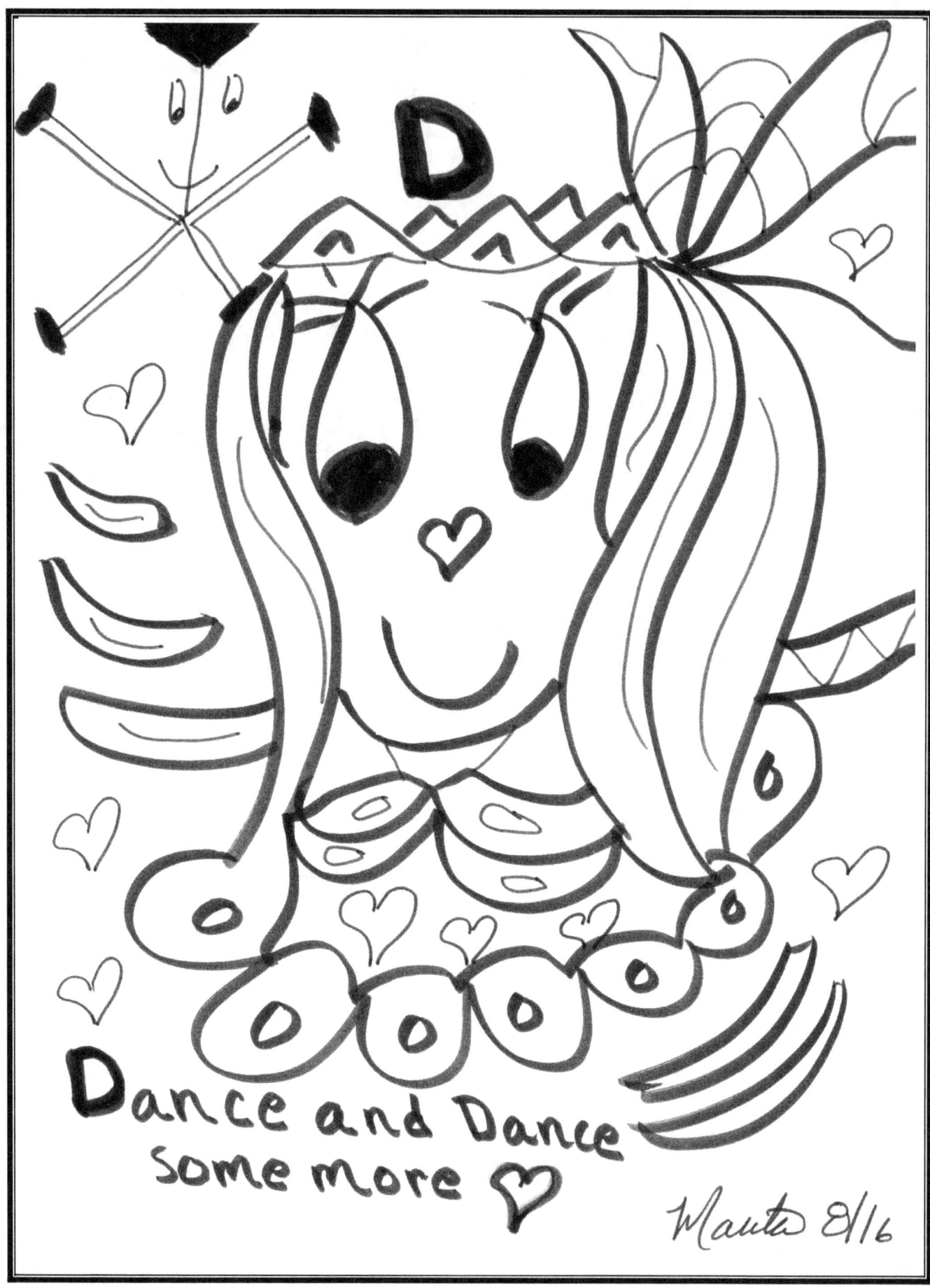

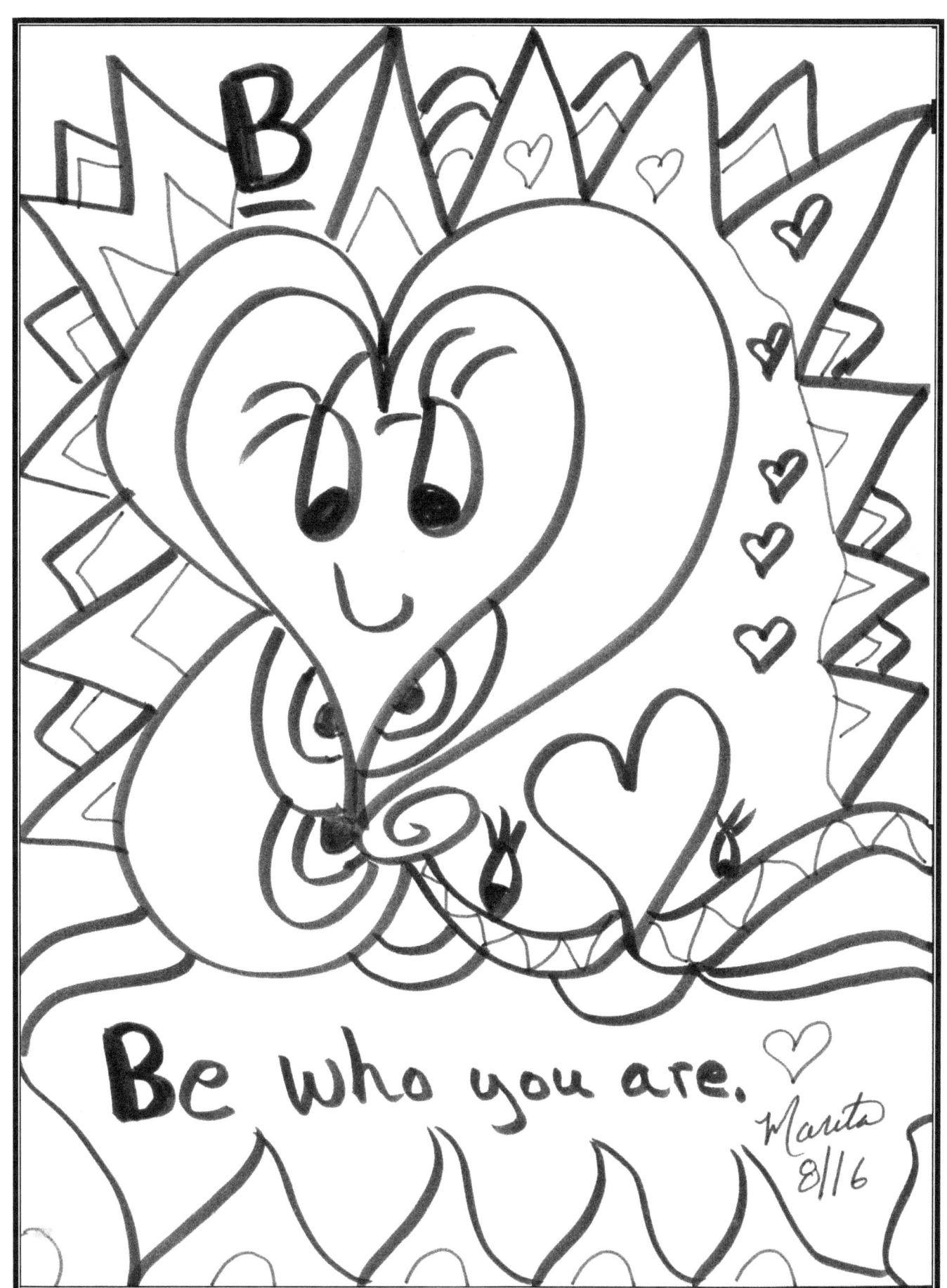

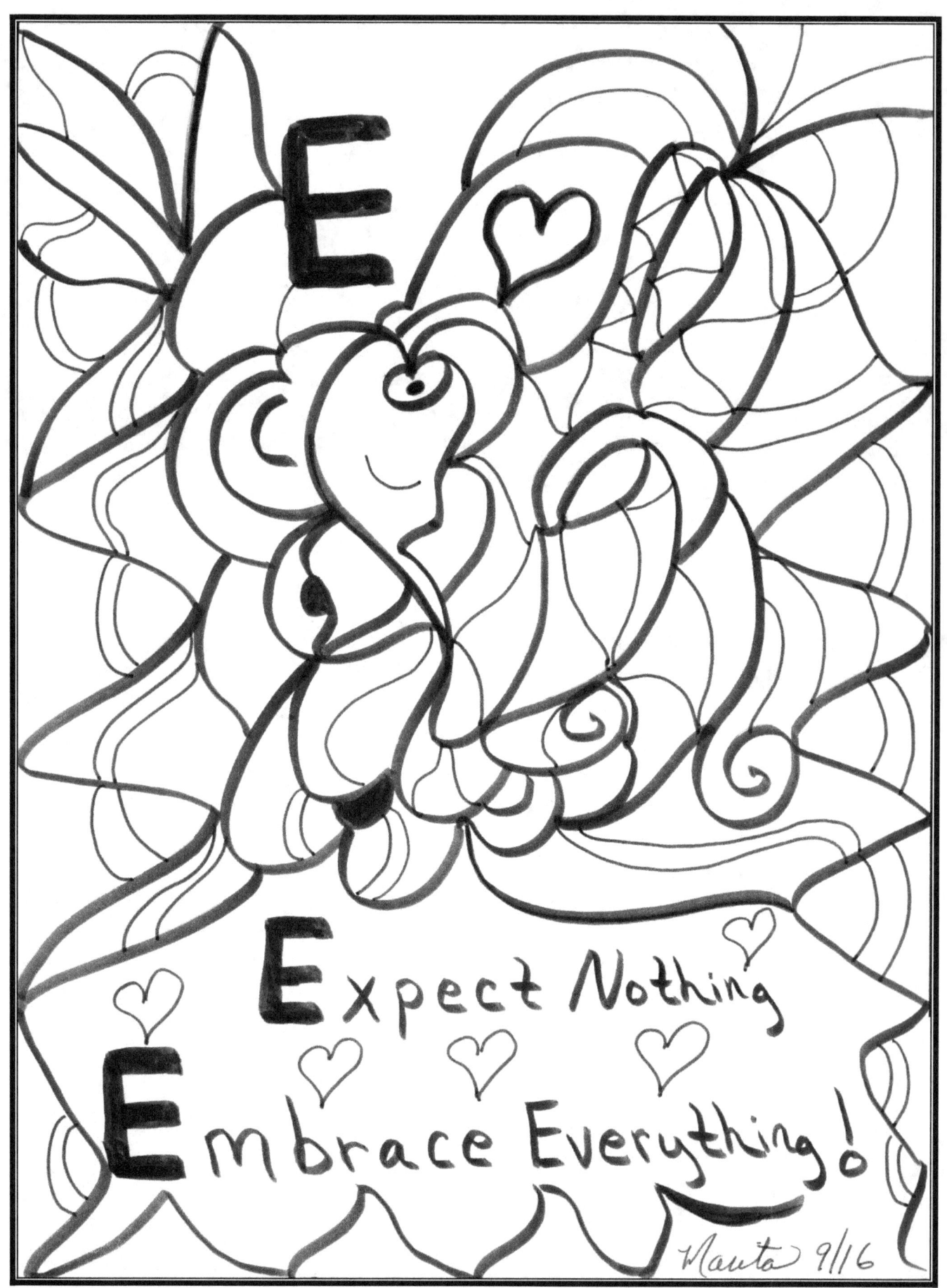

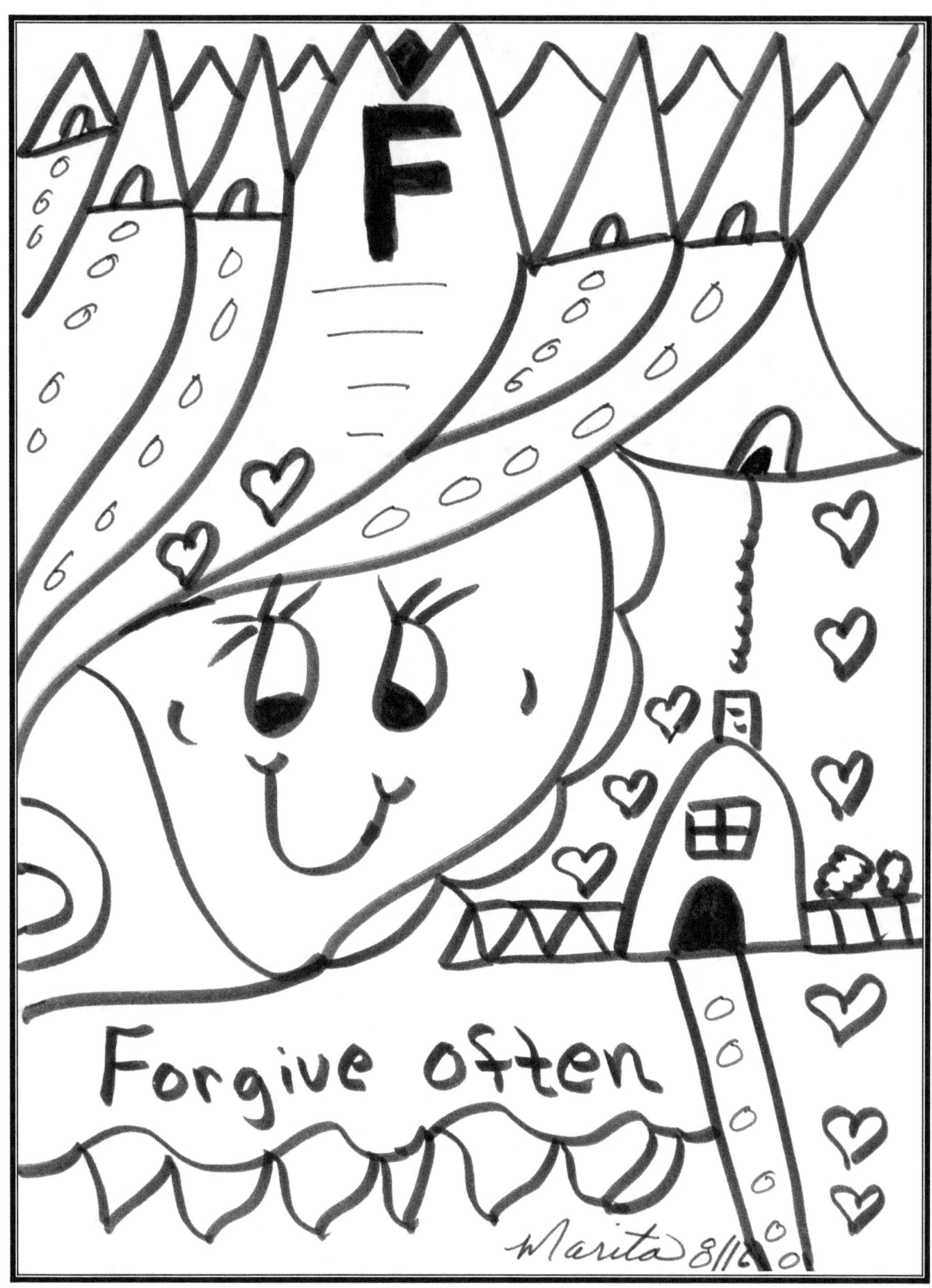

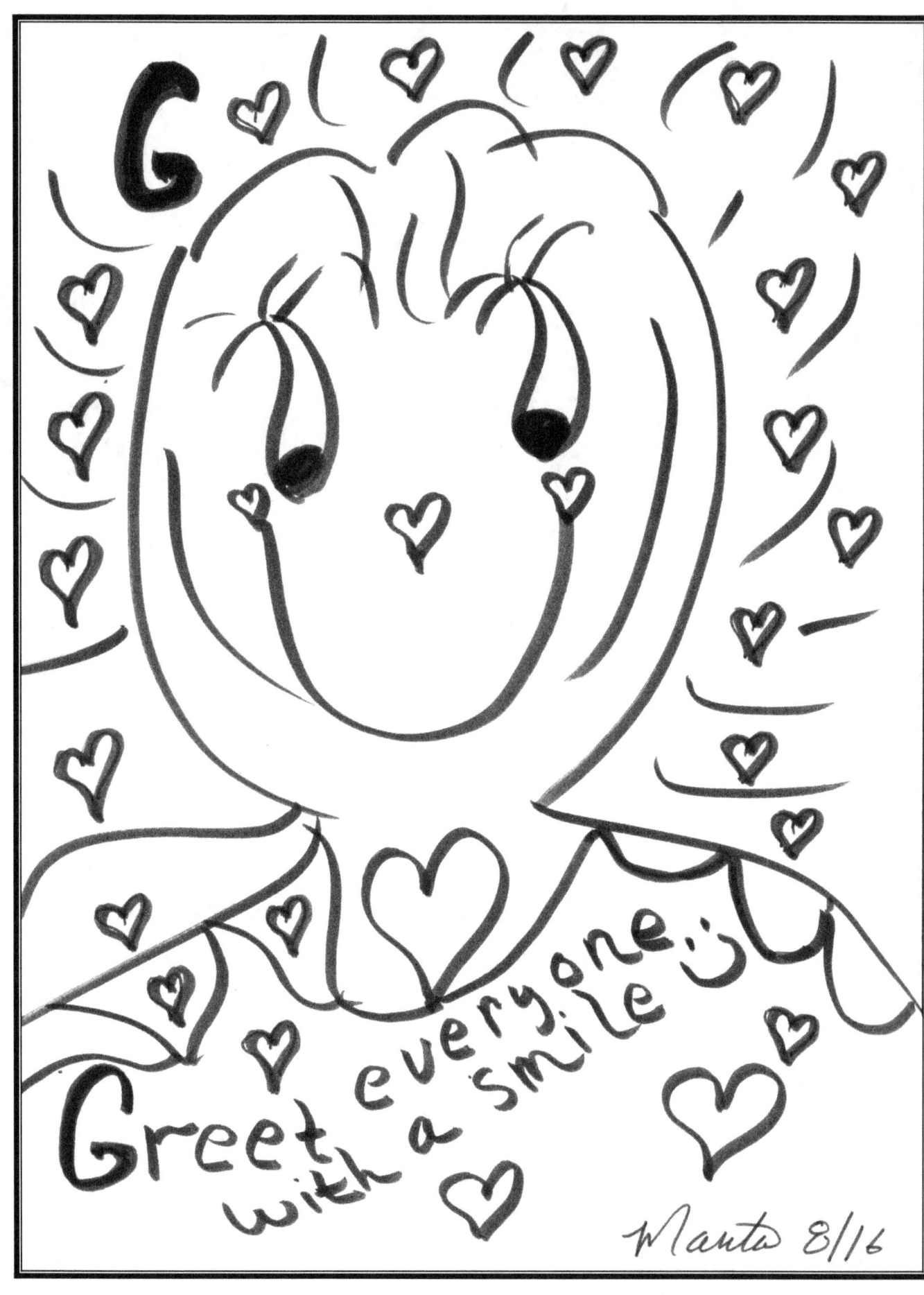

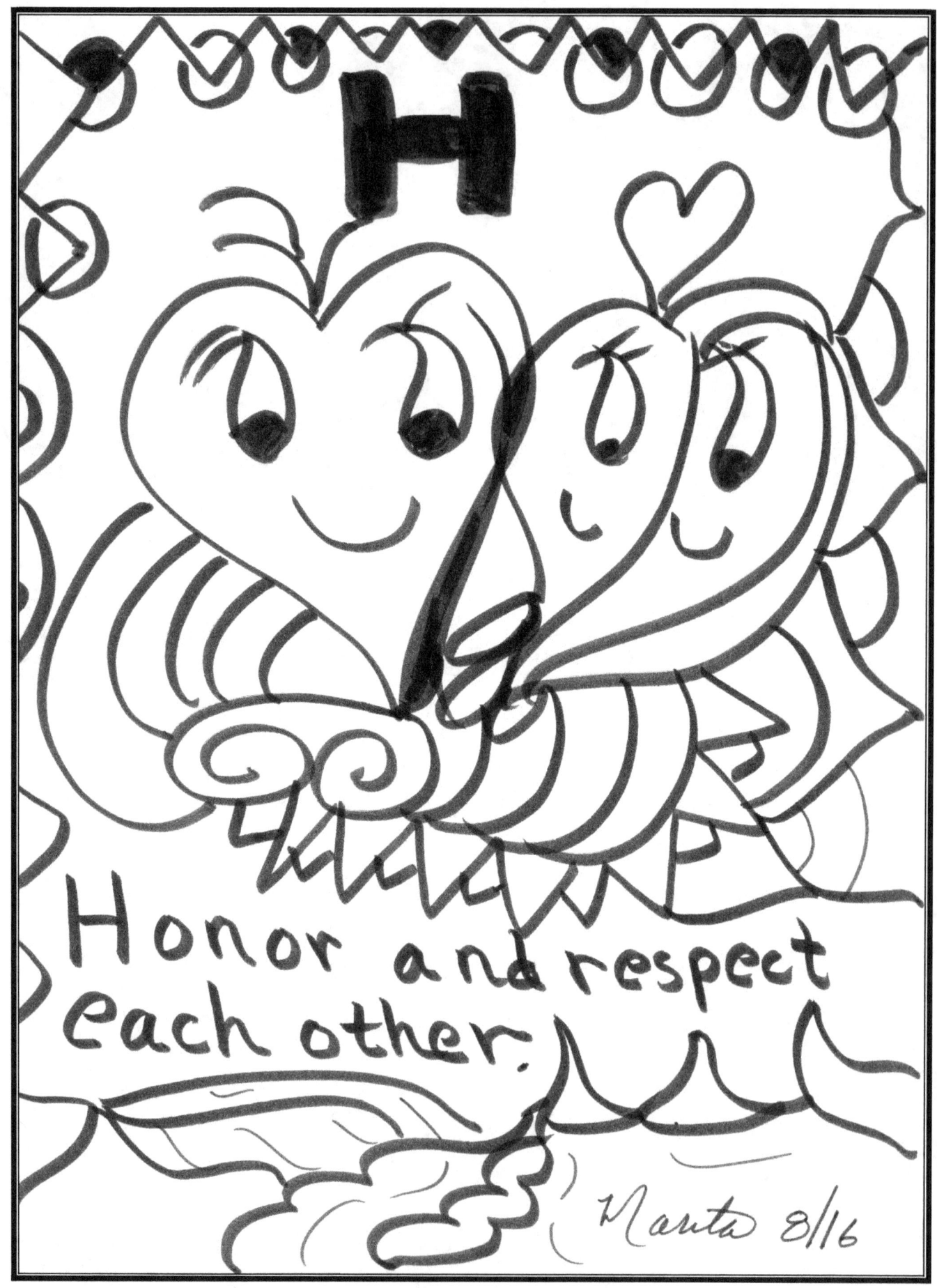

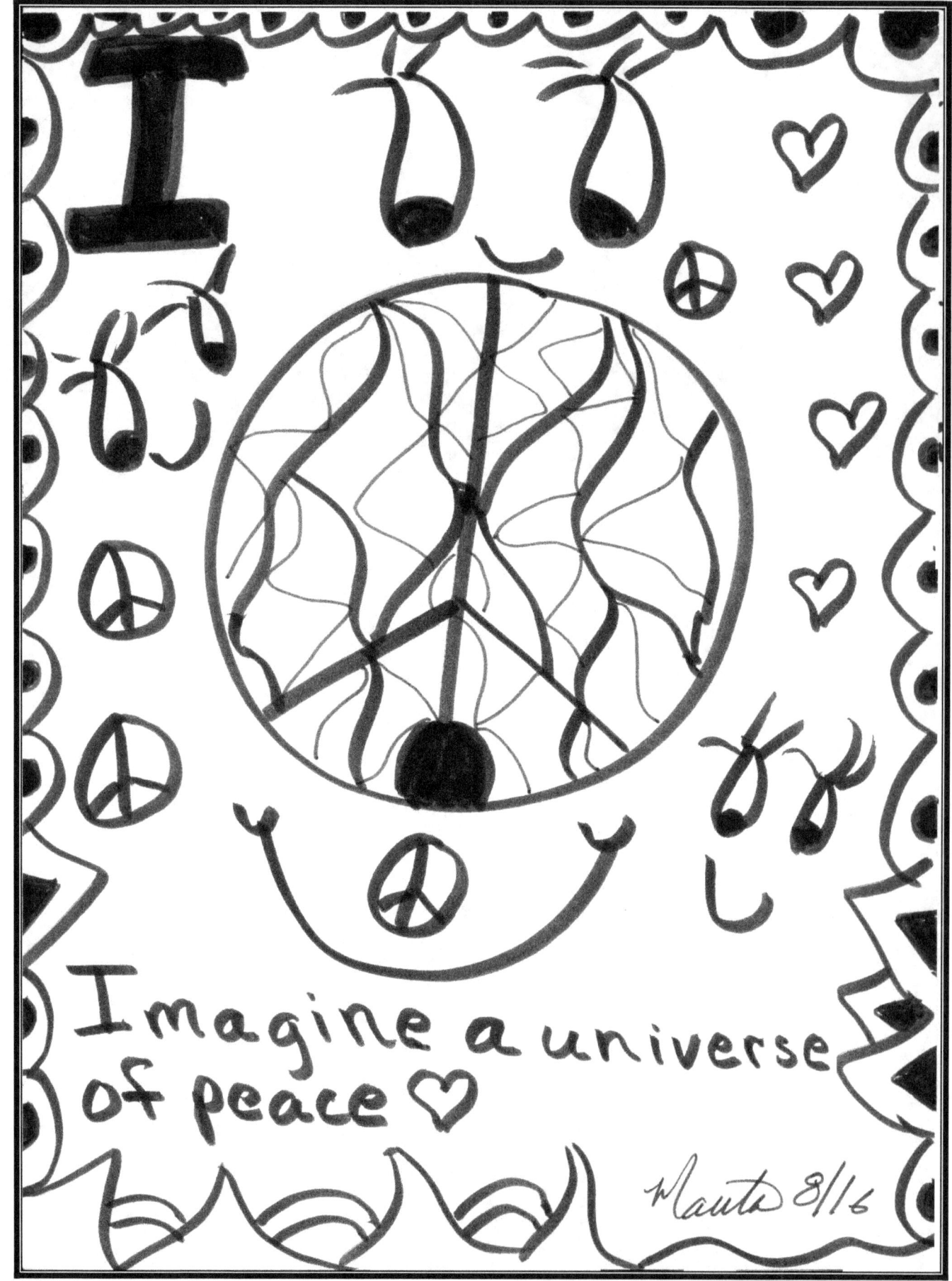

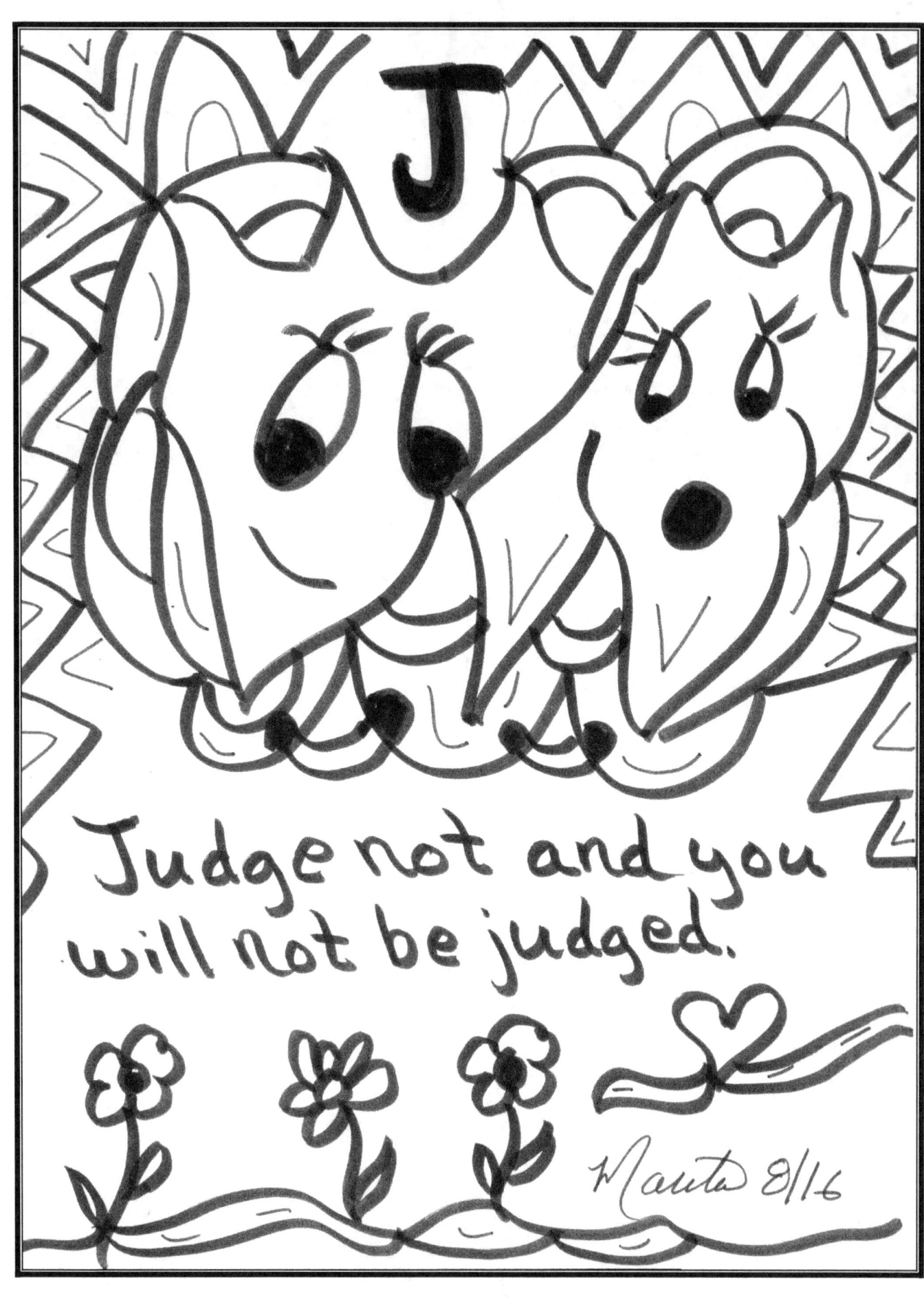

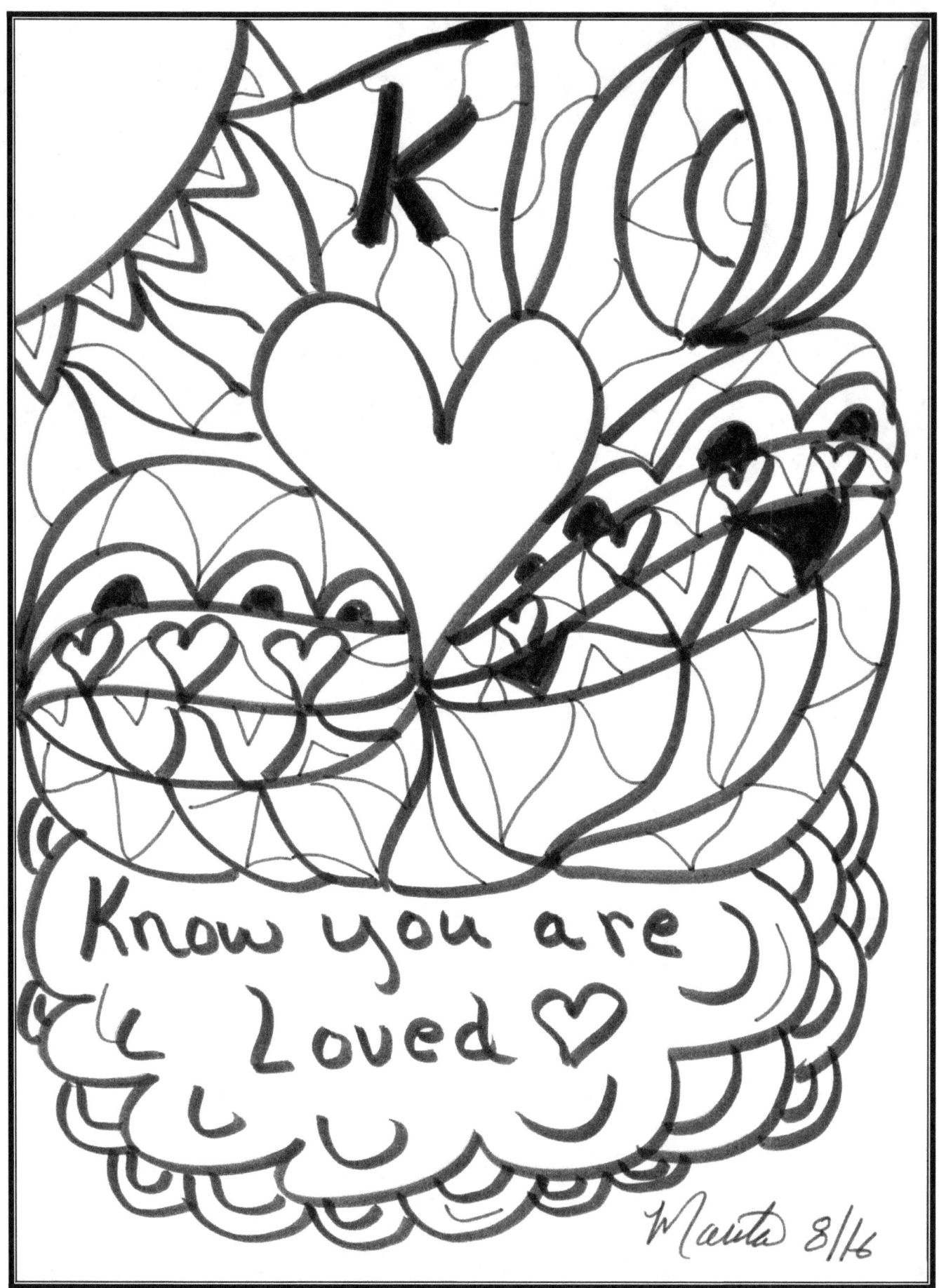

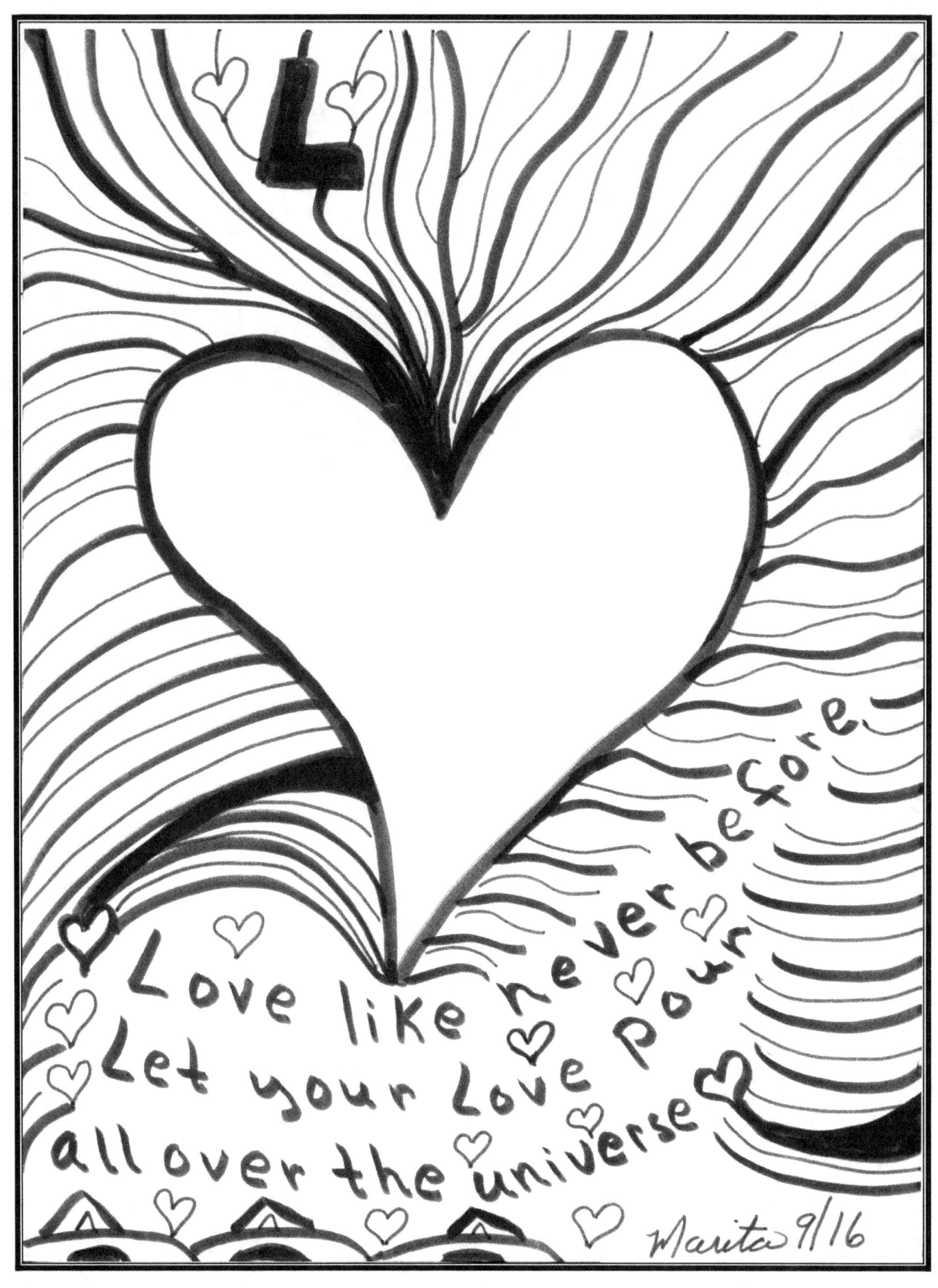

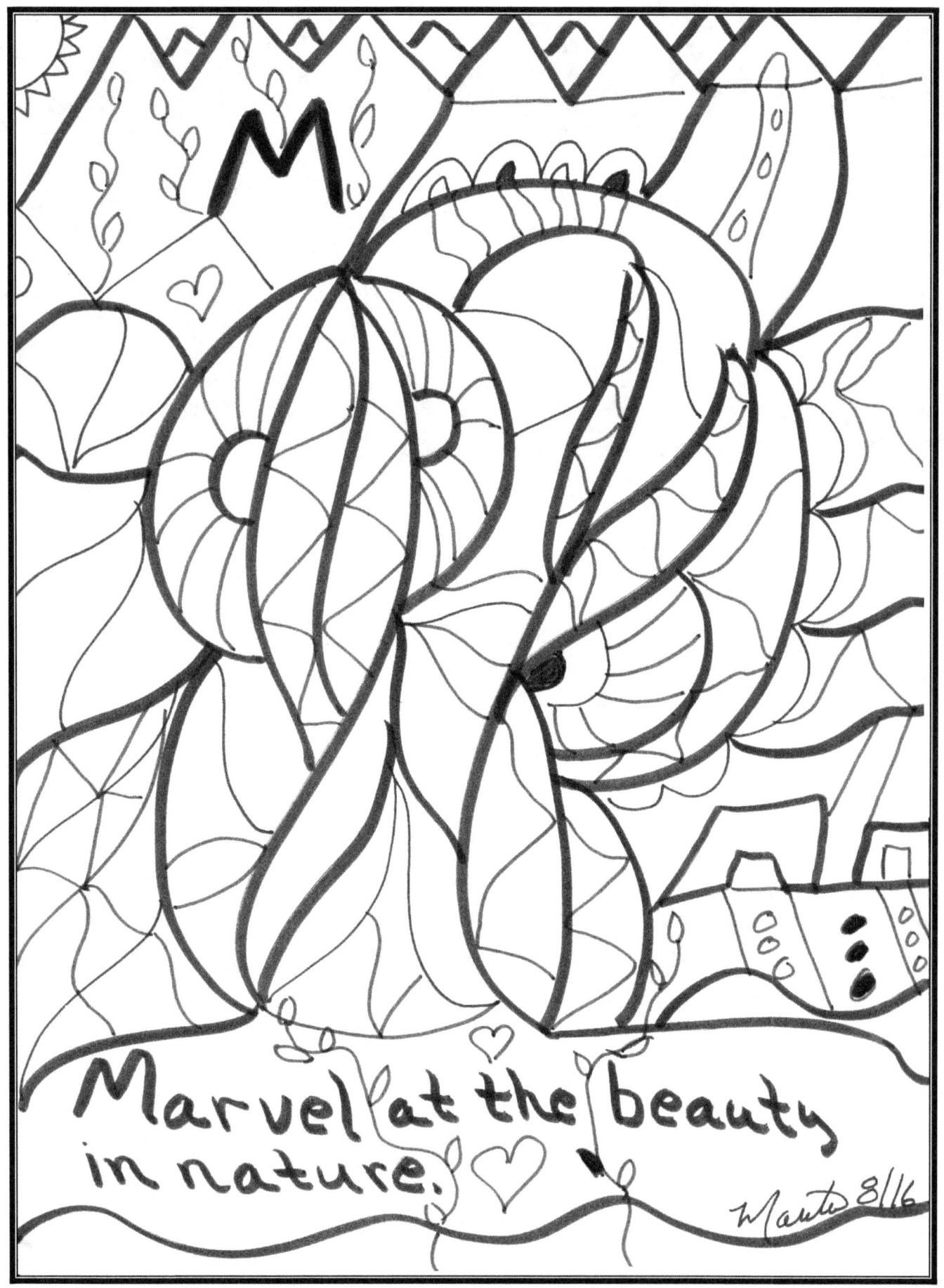

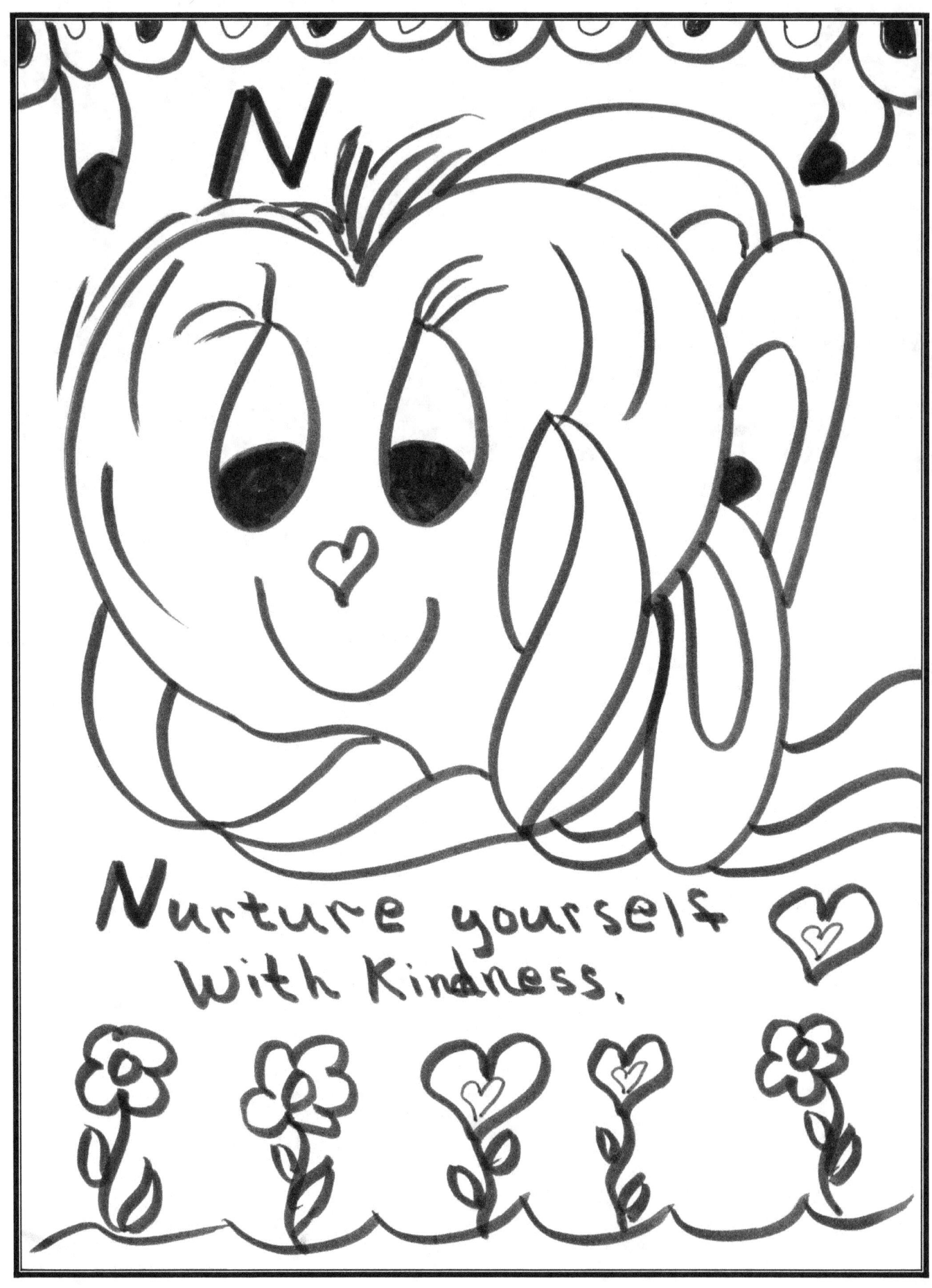

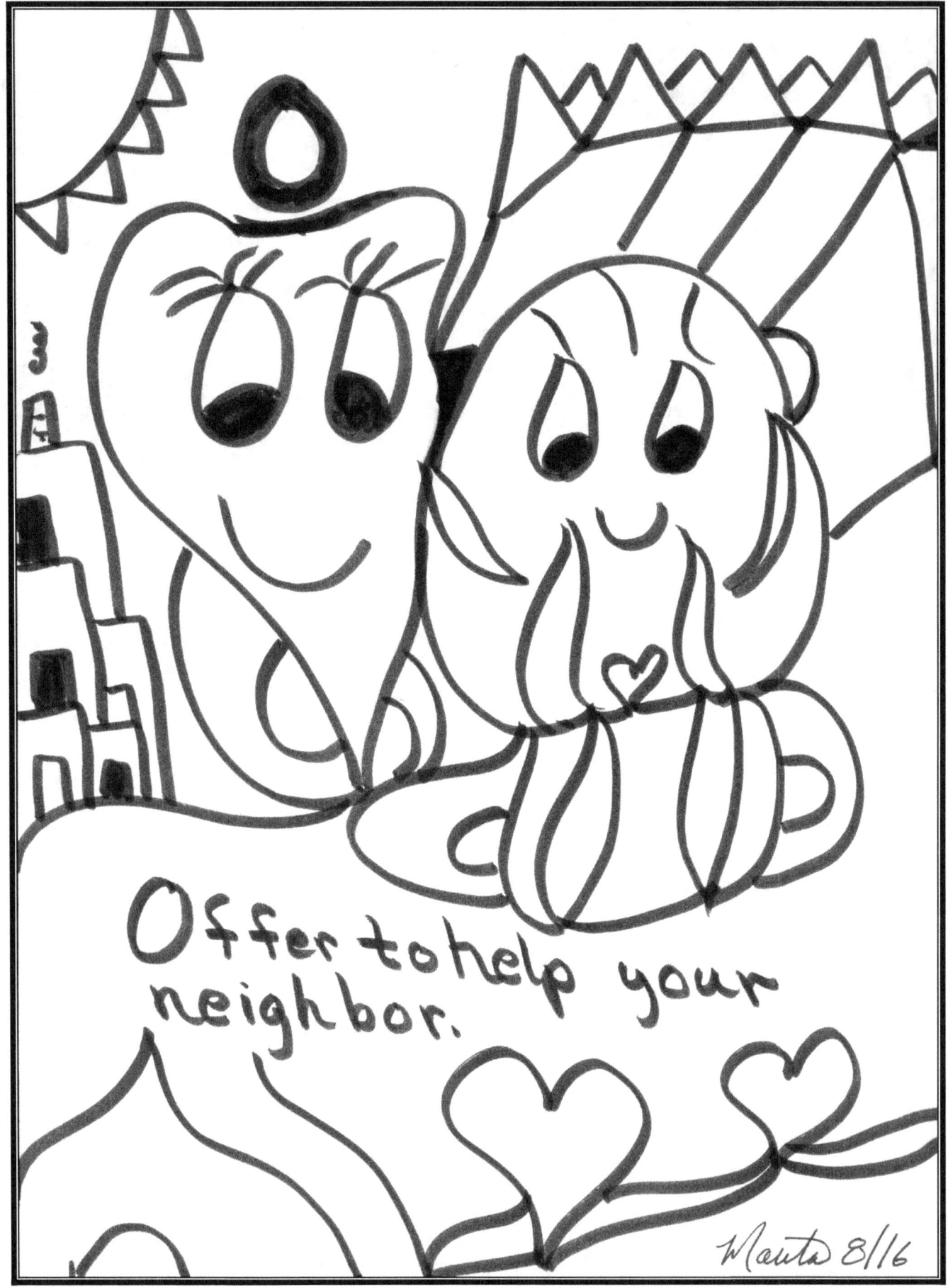

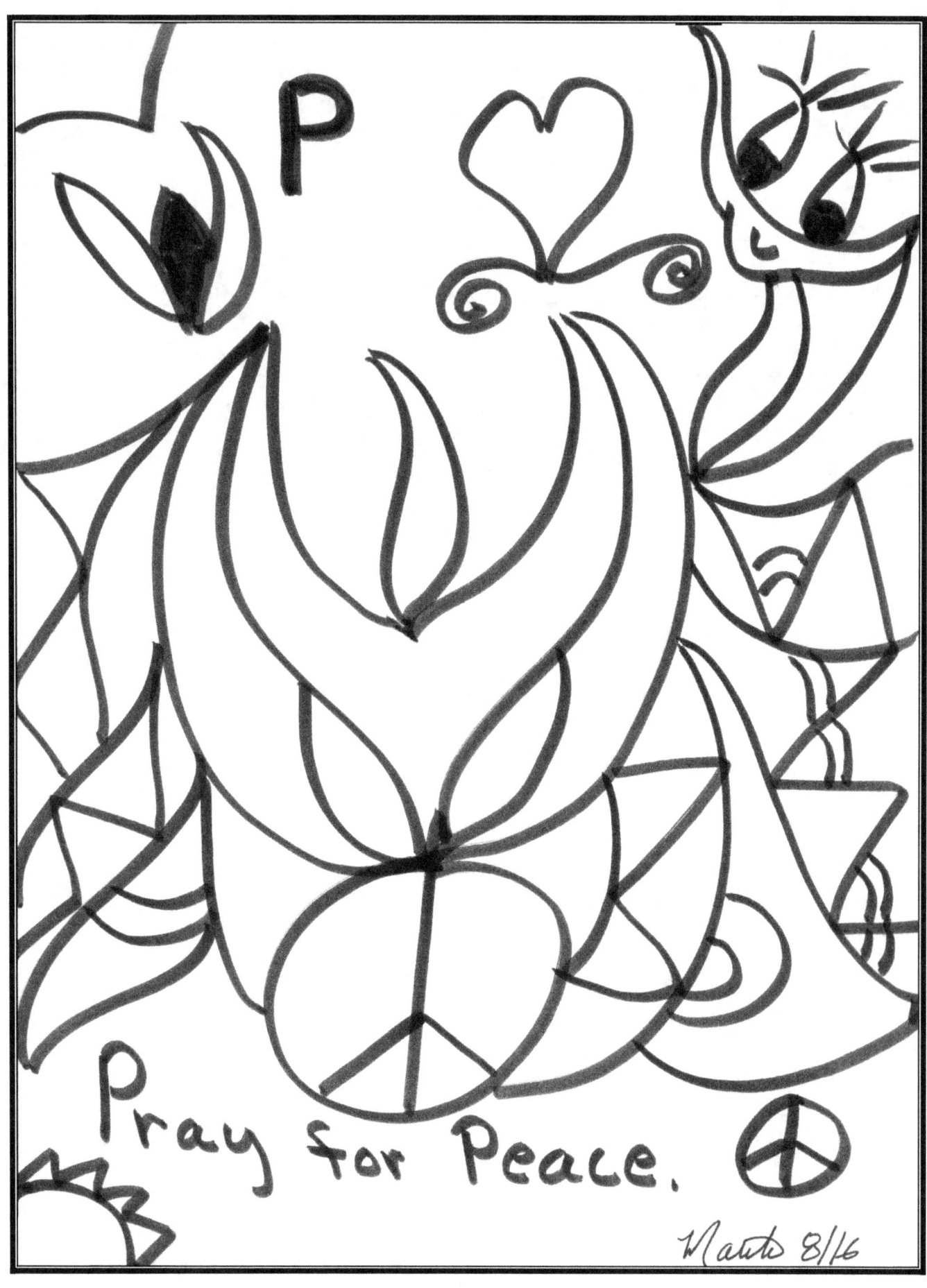

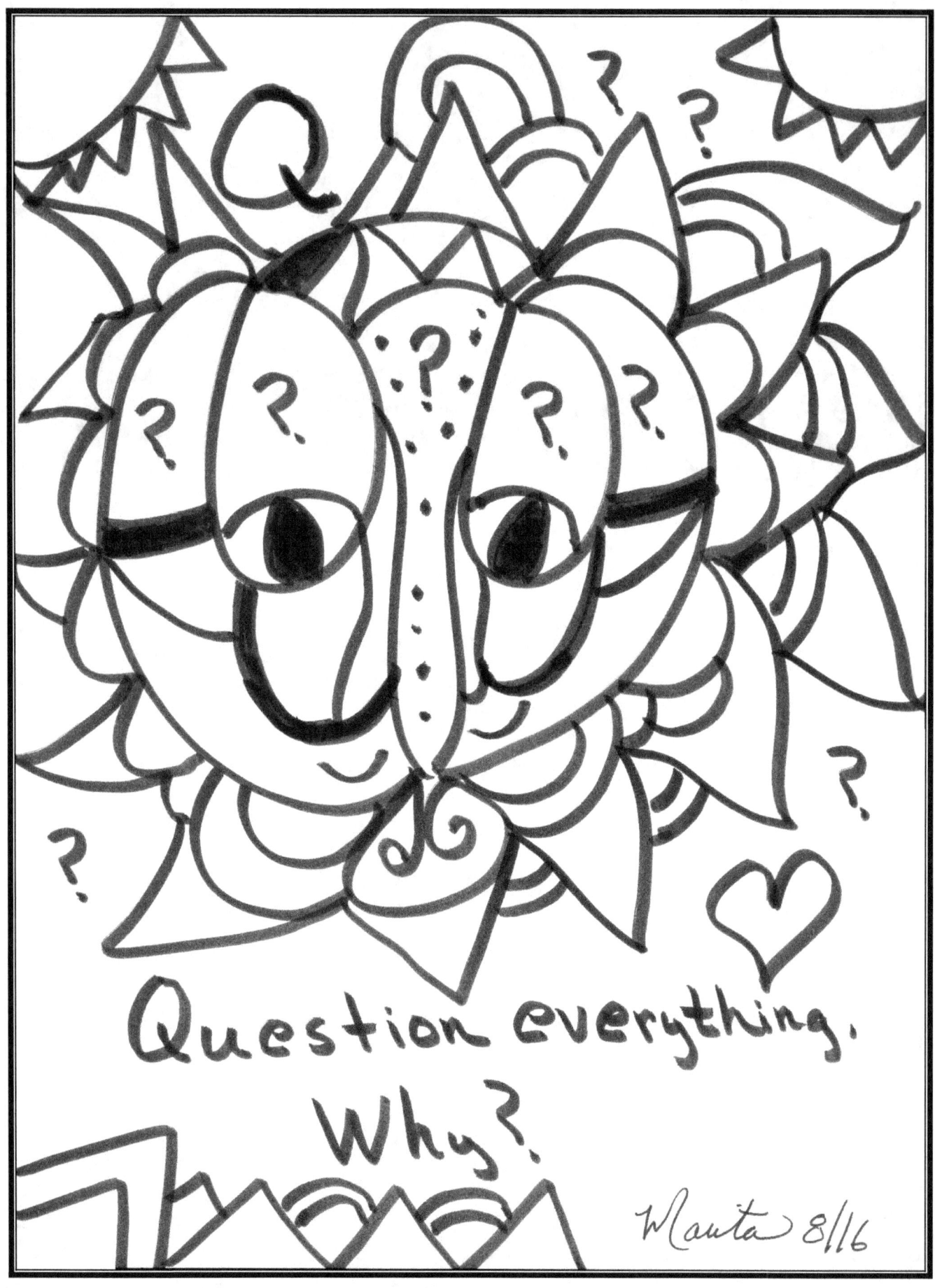

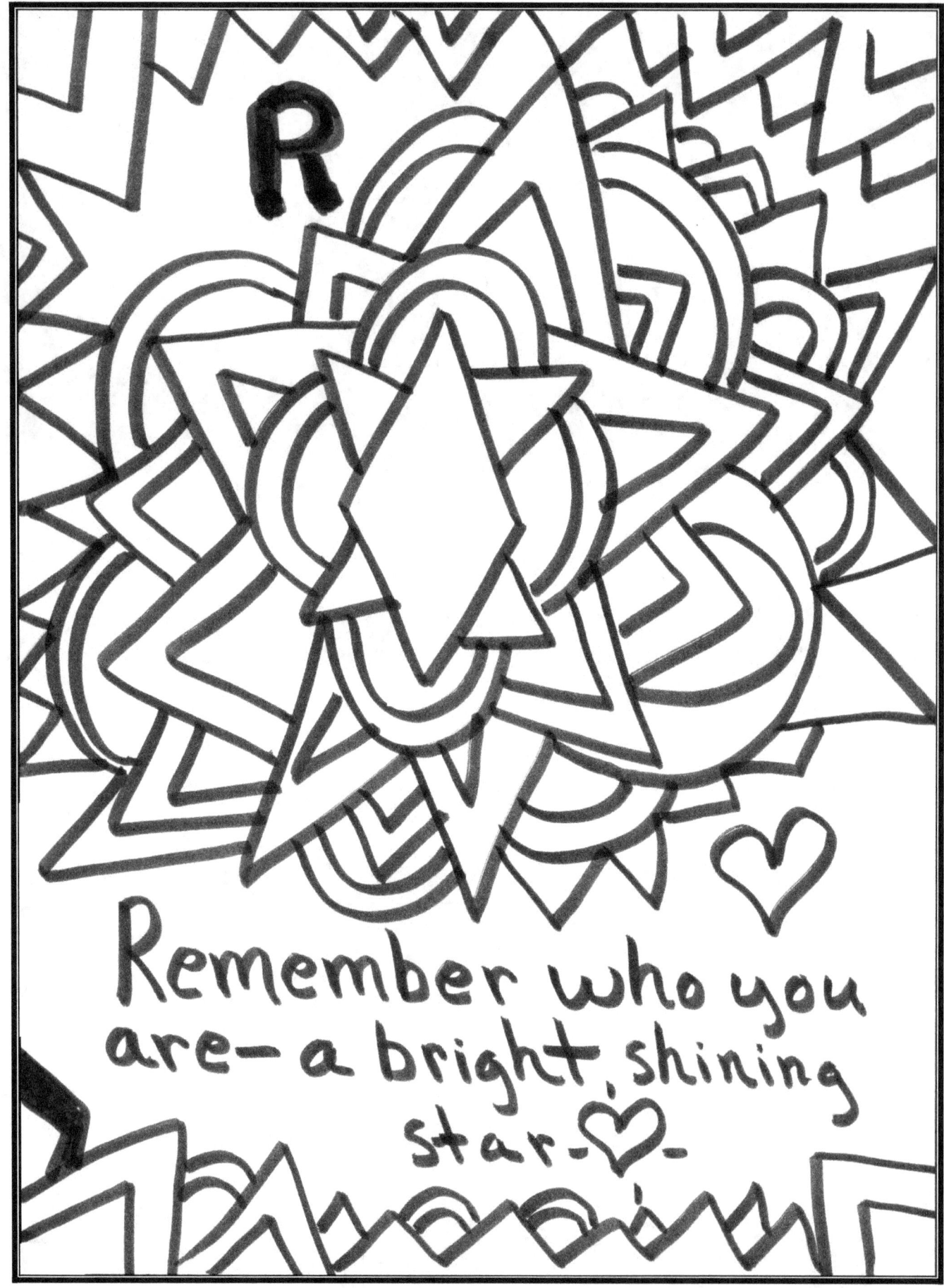

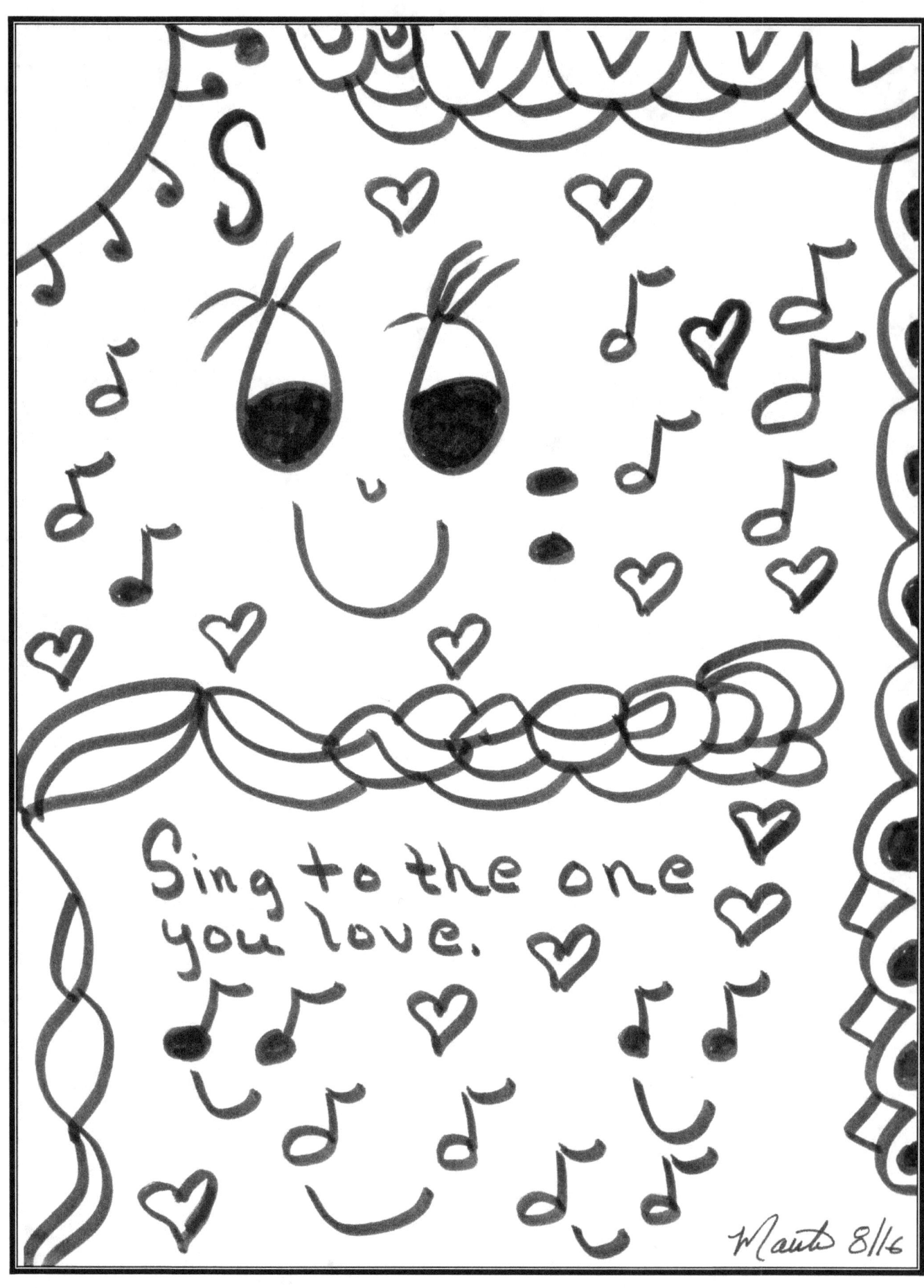

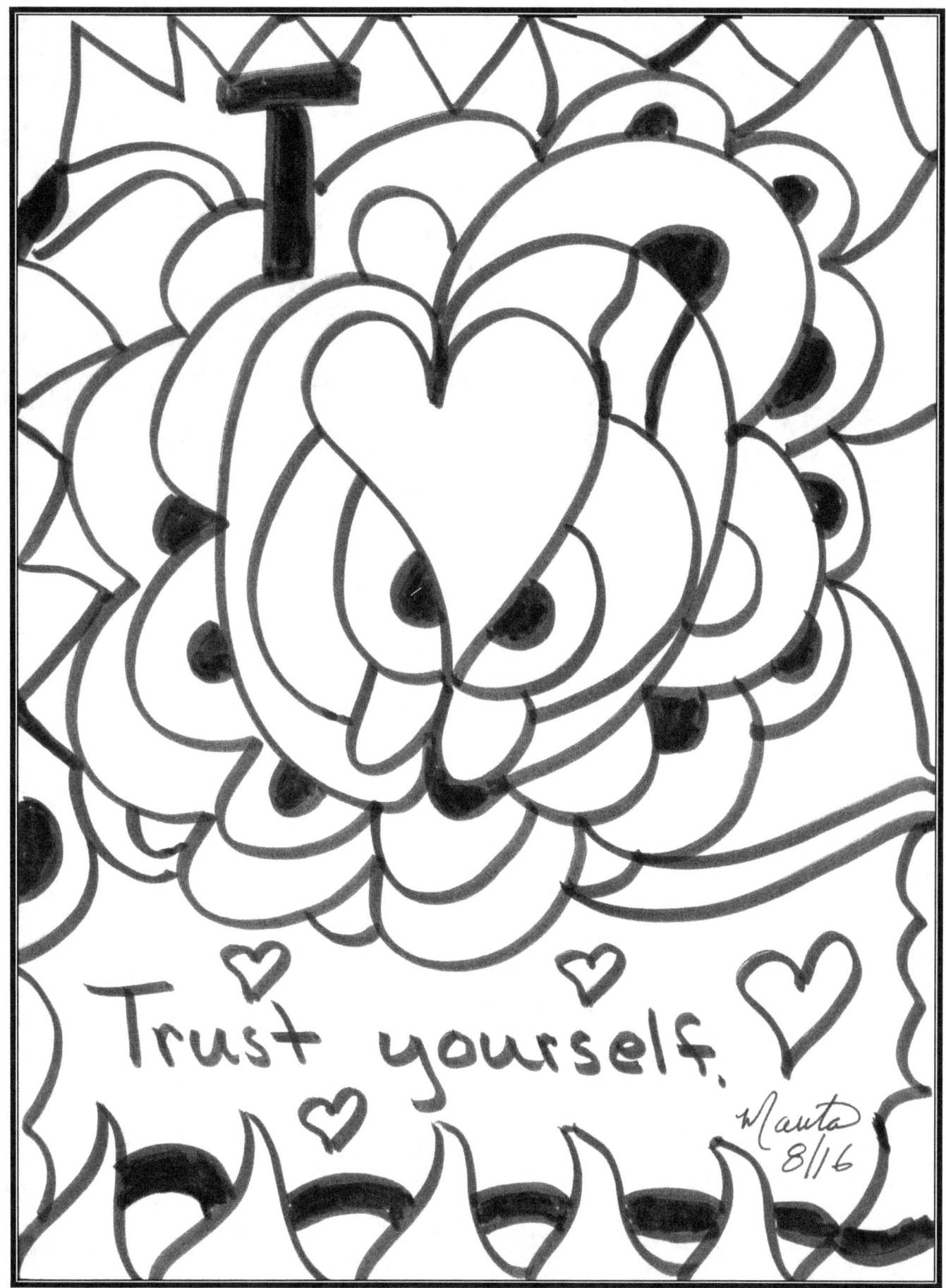

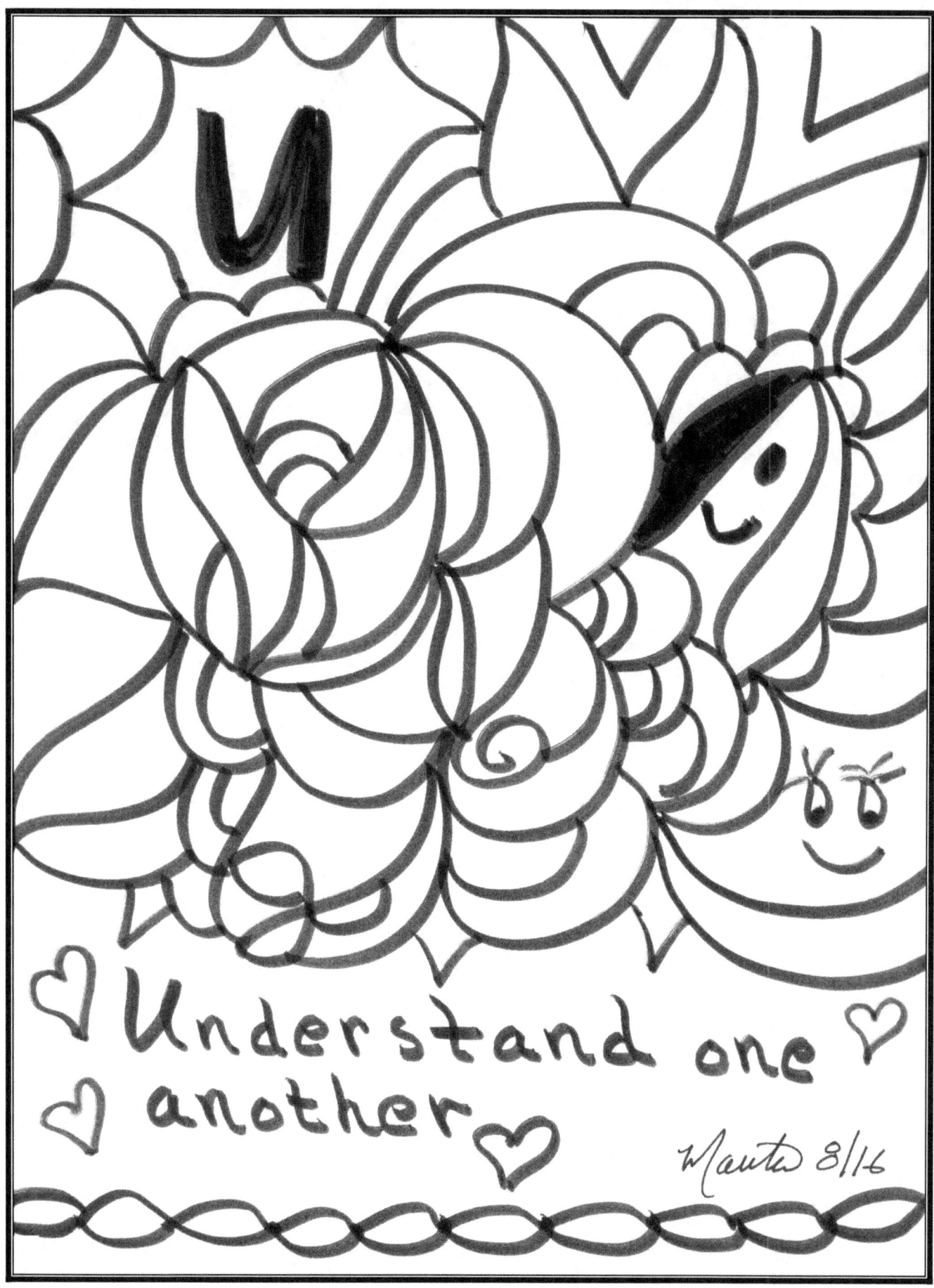

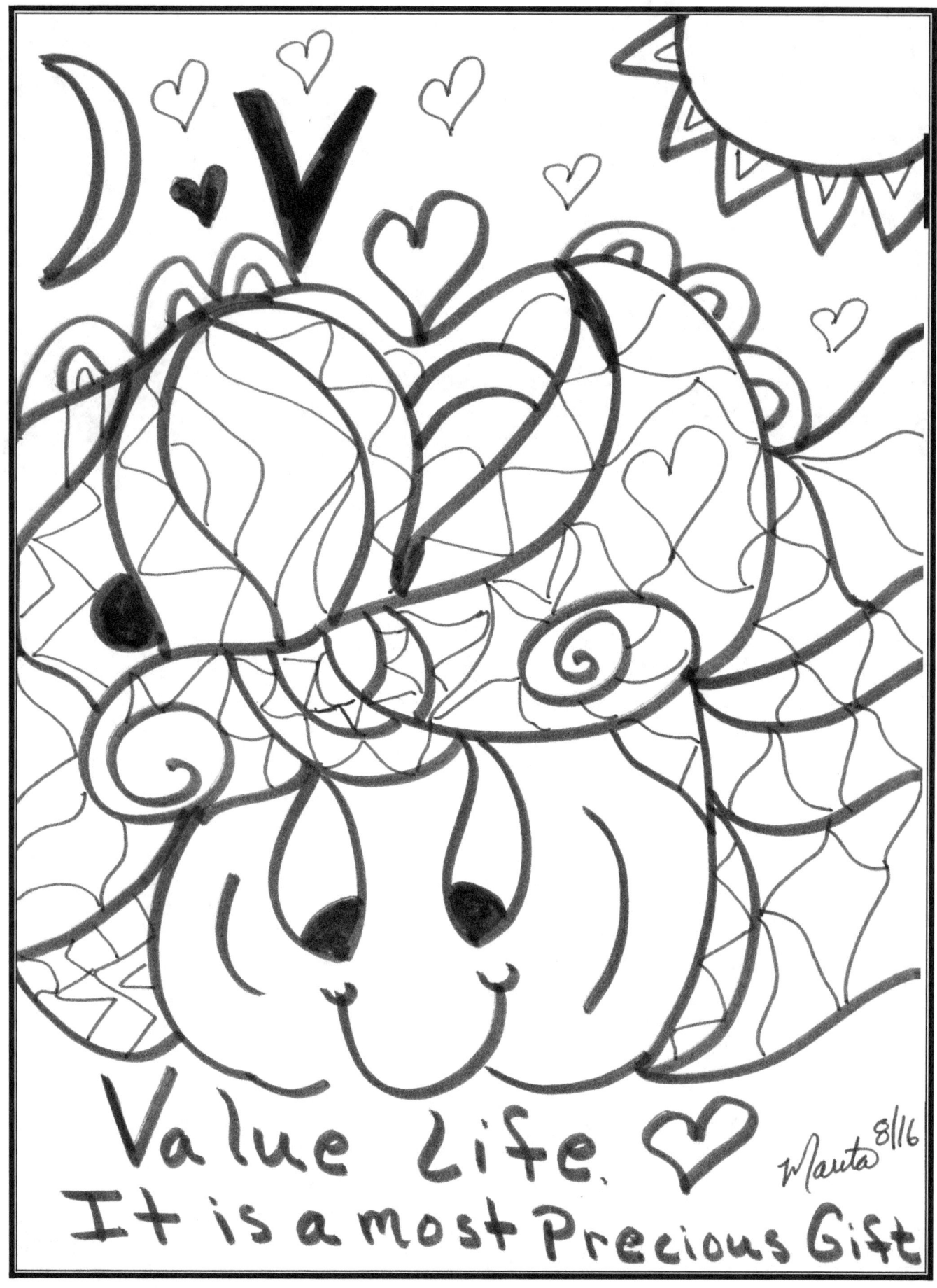

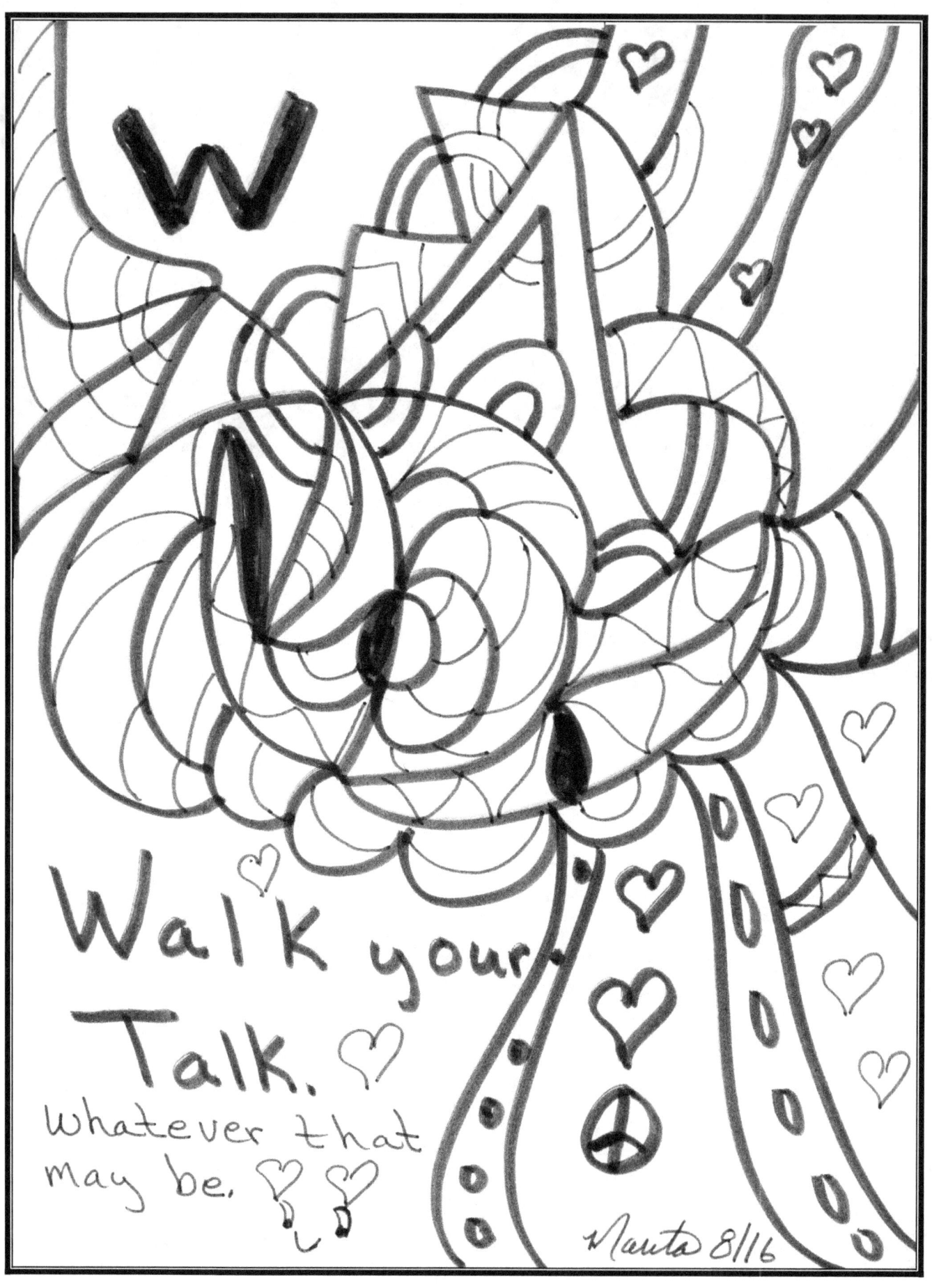

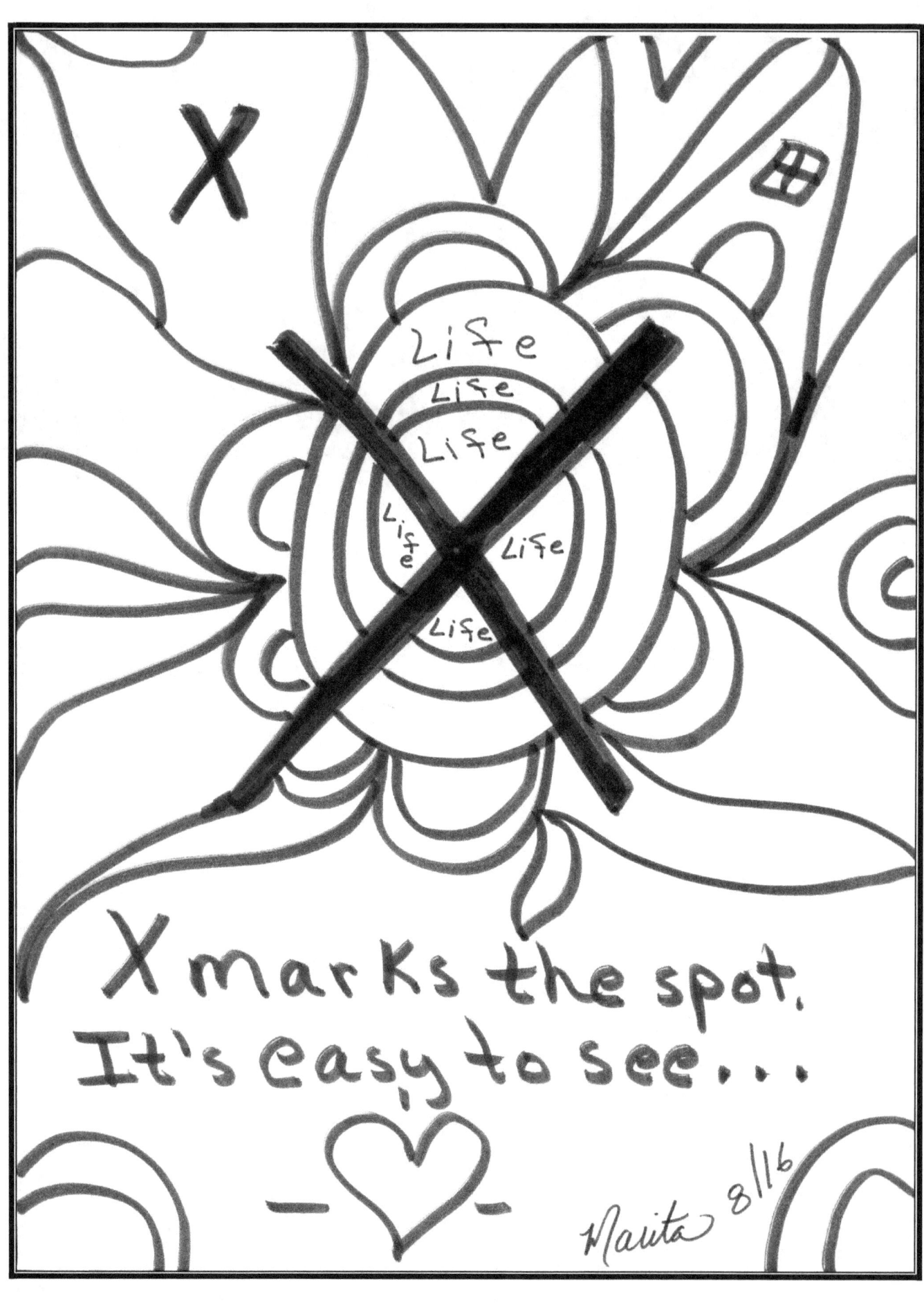

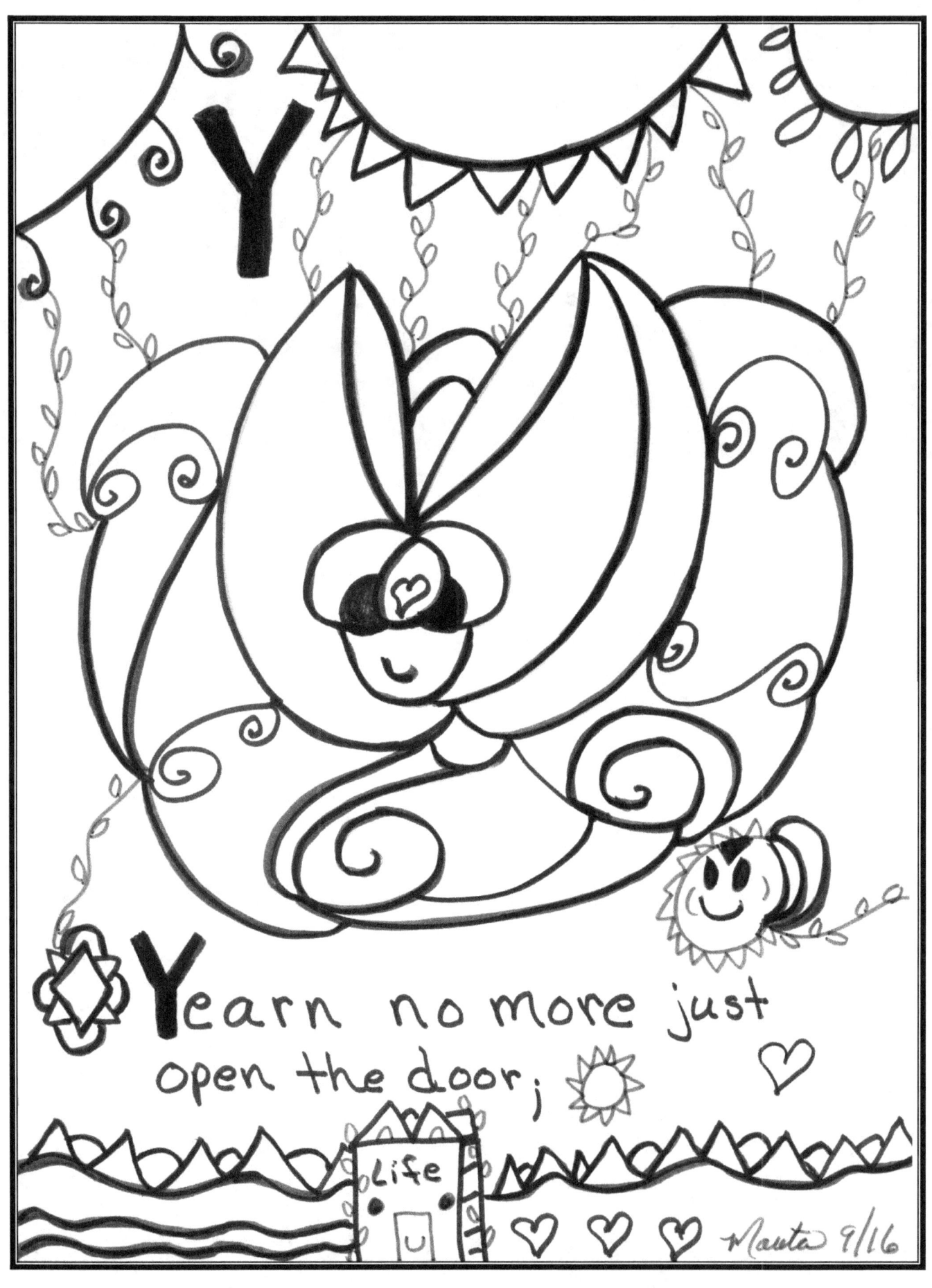

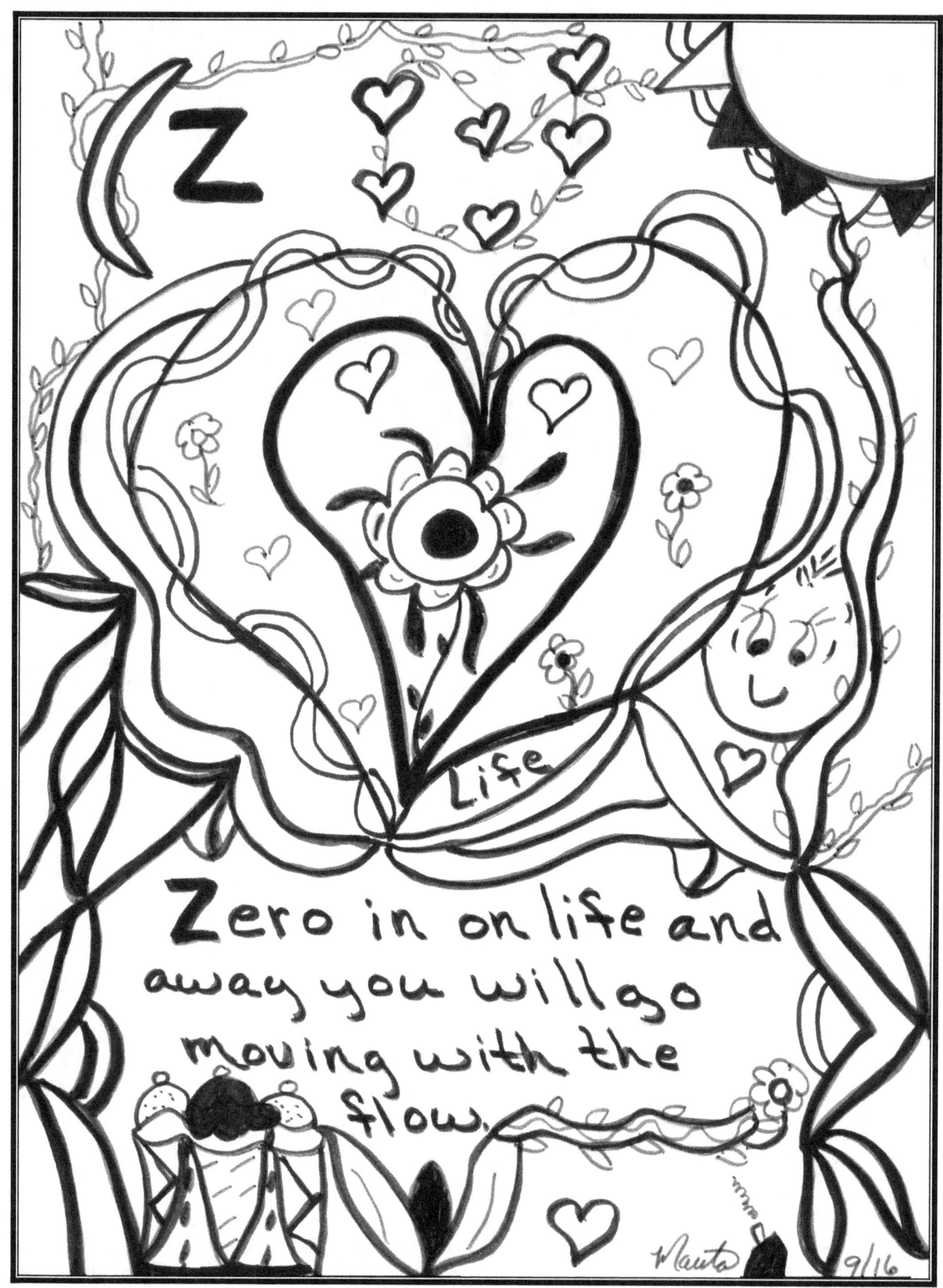

ABOUT THE AUTHOR/ARTIST

Marita's journey began in Knoxville, Tennessee, utilizing her art and poetry as an avenue to find forgiveness allowing personal growth and self-awareness to blossom.

In 2009, Marita loaded all of her personal possessions into her Honda Civic and headed for Sedona, Arizona, trusting her inner guidance to follow her creative path while being of service to others teaching forgiveness through art.

She has created countless energy portraits for people from around the world, authored numerous books which include her artwork and has been a guest speaker in cities across the country.

She was commissioned to do an article with artwork for Unity magazine celebrating mothers in the May/June 2015 issue.

She conducts art workshops across the country and is available for speaking engagements to share her story.

For more information regarding art workshops, individual sessions, custom coloring books or speaking engagements please contact Marita Gale at maritagale@gmail.com or wisdomandartfromtheheart.com.

www.ingramcontent.com/pod-product-compliance
Lightning Source LLC
Chambersburg PA
CBHW081608200526
45169CB00021B/2658